A.B. & W.T. Westervelt

American Antique
WEATHER VANES

The Complete Illustrated Westervelt Catalog of 1883

Dover Publications, Inc., New York

Publisher's Note

Traditional bearers of heraldic and church insignias atop the castles and cathedrals of medieval Europe, weather vanes have been popular additions to American buildings beginning with handcrafted weathercocks in Colonial times. In the late nineteenth century, the growing power, wealth and adventurous spirit of a youthful America were reflected in the stately rooftop spires that served as trade signs, good luck emblems, decorative status symbols and, of course, indicators of wind direction. In this important 1883 mail-order catalog, A. B. and W. T. Westervelt, manufacturers of varied metal goods, advertised their offering of over 550 copper vanes and finials. The prices listed here are no longer valid, but antique collectors, historians and craftsmen will make good use of these engravings of the bannerets, ships, bulls and racing horses that crowned American buildings in the Victorian era. (The last two pages in the present edition are the original front and back of the paper cover of the catalog; the page facing this one reproduces the original title page.)

Published in Canada by General Publishing Company, Ltd., 30 Lesmill Road, Don Mills, Toronto, Ontario.
Published in the United Kingdom by Constable and Company, Ltd., 10 Orange Street, London WC2H 7EG.

This Dover edition, first published in 1982, is an unabridged and unaltered republication of the work originally published by A. B. & W. T. Westervelt in 1883. The Publisher's Note is new in the present edition.

DOVER *Pictorial Archive* SERIES

Manufactured in the United States of America
Dover Publications, Inc., 180 Varick Street, New York, N.Y. 10014

Library of Congress Cataloging in Publication Data

A. B. & W. T. Westervelt.
 American antique weather vanes.

 Reprint. Originally published: Illustrated catalogue and price list of copper weather vanes, bannerets, and finials, manufactured by A. B. & W. T. Westervelt. New York : Westervelt, 1883.
 "No. 6."
 1. Weather vanes—United States—History—19th century—Catalogs. I. Title.
NK9585.A2 1982 739'.511'02947471 82-9462
ISBN 0-486-24396-6 AACR2

No. 6.

Illustrated Catalogue

AND

PRICE LIST

OF

COPPER WEATHER VANES, BANNERETS

AND FINIALS,

MANUFACTURED BY

A. B. & W. T. WESTERVELT,

OFFICE AND WAREROOMS:

102 CHAMBERS STREET,

Corner Church Street, NEW YORK.

CUPOLA AND VANE.

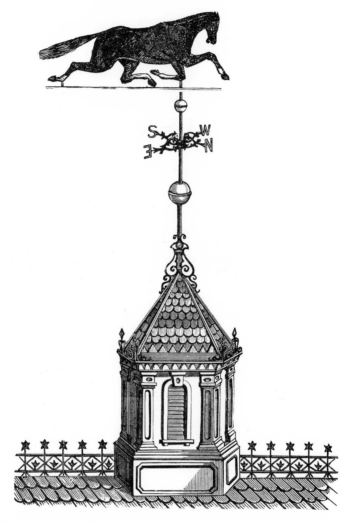

This cut represents a Cupola and Vane, mounted complete, showing the proper position of Balls and Points of Compass. If no compass is at hand to set the cardinal points by, notice that the sun is exactly in the South at meridian (or noon).

DIRECTIONS FOR PUTTING UP VANES.

Bore or cut a hole perfectly perpendicular—care must be taken in this, as a crooked hole will make the Vane stand crooked—the hole should be a little larger than the size of the Spire, wedge in tight and straight. Fill any crevices or joints with White Lead or Cement. The Spire should be set in from 8 to 12 inches, and for a very large Vane, 18 inches to 3 feet.

NOTE.—**Avoid handling the gilding with the bare hands; handle lightly, with soft tissue-paper, cotton or soft cloth.**

All the tools necessary are a screw driver, with which to fasten the Points of Compass and Ring for lower Ball to Spire, and brace and bit or chisel, to make the hole for the Spire.

PREFACE.

In compiling this (the sixth) edition of our Illustrated Catalogue of Weather Vanes, Bannerets and Finials, we have endeavored to include appropriate designs for Churches, Public Buildings, Residences, Stables, Barns, &c., &c., thus making it the most complete work issued; we are, however, continually adding new and original designs to our stock.

Our Vanes are made Entirely of Copper *and* Gilded with the Finest Gold Leaf, *will keep bright, will not corrode, and are perfect indicators of the wind's direction.*

The letters and balls are well gilded, the spires are of wrought iron, with hardened steel spindles for the Vanes to turn upon.

Our Copper Eagles, *from the largest to the smallest, for* Vanes or Architectural *purposes, are full-bodied, the wings of double thickness, and are a perfect representation of the* American Eagle.

The Price of each Vane includes a Wrought Iron Spire with points of Compass, Gilt Letters and Balls.

Vanes of any design or size, to order on short notice and at reasonable rates.

We would caution our customers and the public against being deceived by Vanes which are now being made, (copied after our original designs,) which are manufactured of Sheet Zinc and covered with a thin solution of Copper with Zinc Tubing, *unlike our Vanes, which are made of Sheet Copper and Brass Tubing.*

Special attention given to the erection of Lightning Rods, in connection with our Vanes, Crestings, Finials and Terminals. All the varieties of Galvanized Iron, Copper covered and Solid Copper Rods with Fixtures, furnished on short notice, (see page 99.)

With the view of simplifying the ordering of our Vanes, please describe each design by the name, &c., given in this book; always specifying the Figure Number, *size of Vane, and number of this catalogue (No.* 6); *also, be careful to give full and particular shipping directions.*

Experienced persons will be sent to receive instructions, to give practical information and take orders.

It will be our endeavor to ship all goods with promptness, and careful attention is given to packing.

We make our grateful acknowledgments to our customers and friends for past favors, and trust to merit their future patronage.

Respectfully

A. B. & W. T. WESTERVELT.

ST. JULIAN.

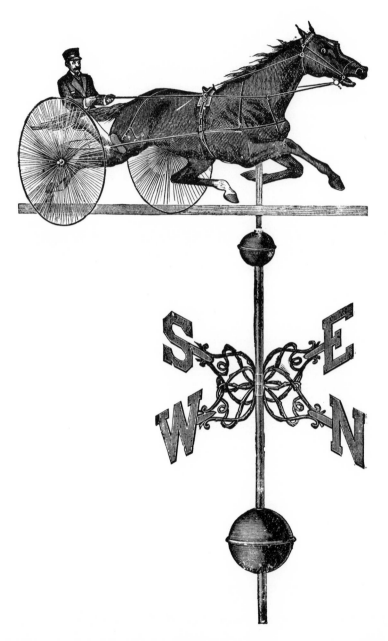

No. 301. New design, 39 inches long, full bodied$44 00

" 302. " " 46 " " with Sulky and Driver................... 62 00

" 303. " " 32 " " swell bodied............................ 26 00

☞ All our Vanes are made of copper, and gilded with finest gold leaf.

MAUD S.

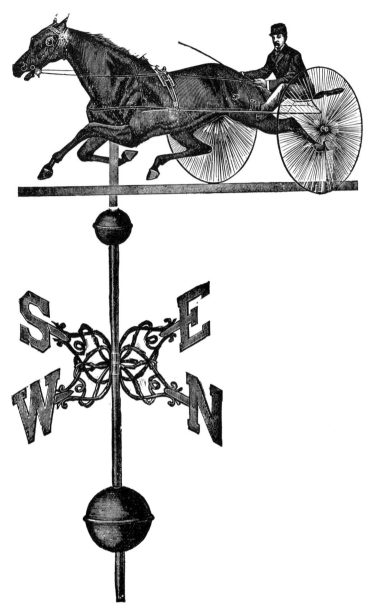

No. 304. New design, 36 inches long, full bodied ... $42 00

" 305. " " 44 " " with Sulky and Driver 60 00

" 306. " " 31 " " swell bodied.......... 25 00

☞ All our Vanes are made of copper, and gilded with finest gold leaf.

LARGE 48-INCH ETHAN ALLEN.

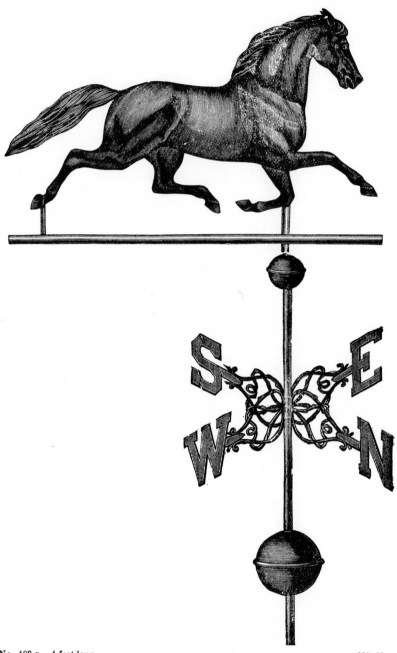

No. 189 C. 4 feet long.. $75 00
" 189 D. 4 " " with Jockey... 85 00
" 189 E. 5 " " " Sulky and Driver............................ 100 00
" 189 F. 5 " 6 inches, with Wagon and Driver.................. 125 00

☞All our Vanes are made of **copper**, and gilded with finest gold leaf.

GEORGE M. PATCHEN.

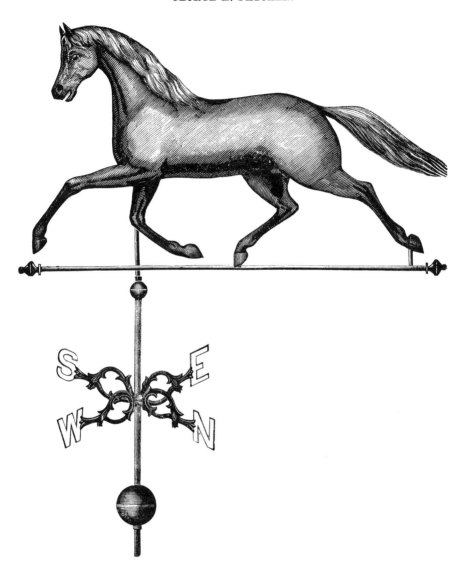

No. 186. 3 feet 6 inches long, swell bodied.. $40 00

" 187. 4 " 4 " " with Sulky and Driver............................ 60 00

" 187½. 5 " long, with Wagon " " 65 00

☞ The price of each Vane includes an iron spire, appropriate letters, and balls complete.

BLACK HAWK.

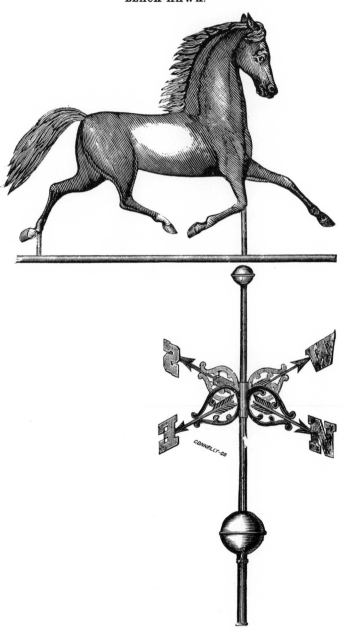

No. 181. 26 inches long..$17 00
" 182. 30 " " with Sulky and Driver..................................... 27 00
" 182¼. 33 " " .. 35 00
" 182A. 40 " " with Sulky and Driver..................................... 45 00
" 182B. 44 " " " Wagon " 50 00

☞ All our Vanes are made of copper, and gilded with finest gold leaf.

NEW DESIGN.—STALLION.

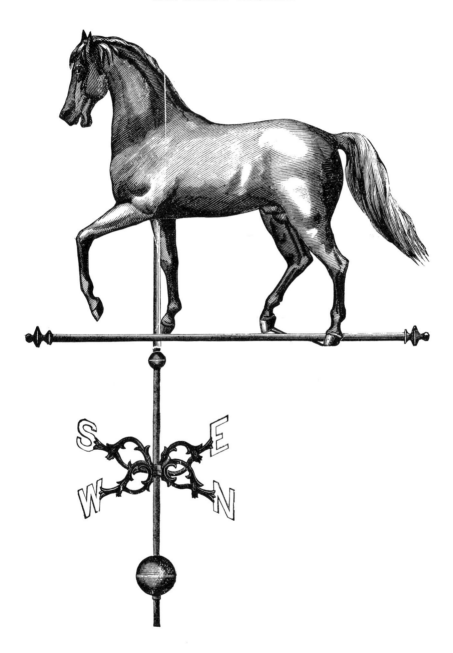

No. 163. 28 inches long, full bodied_____$50 00

☞All our Vanes are made of copper, and gilded with finest gold leaf.

ETHAN ALLEN.

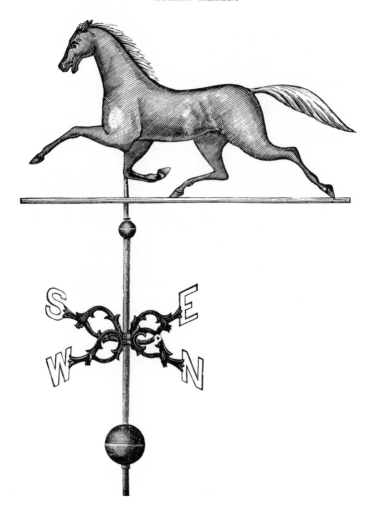

Large, Handsome, Showy Horse Vane, at a Low Price.

SWELL BODIED, COPPER.

No. 189. 31 inches long _____ $20 00
 " 189½. 36 " " with Sulky and Driver _____ 30 00
 " 189A. 31 " " " Jockey _____ 25 00
 " 189B. 39 " " " Wagon and Driver _____ 35 00

☞ All complete as above, with Spire, Letters and Balls.

Note.—Our Vanes are gilded with finest gold leaf, and on copper, warranted to stand the weather in any climate, and not tarnish or corrode.

HAMBLETONIAN.

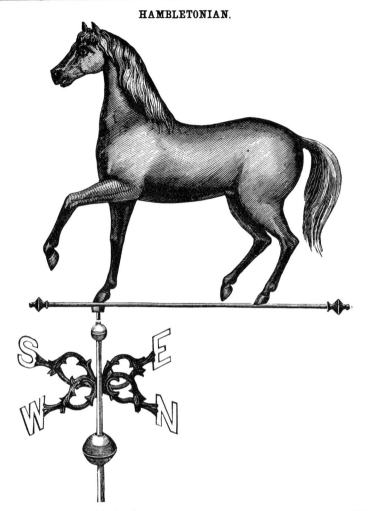

No. 166. New design, 26 inches long _ $25 00

ARABIAN.

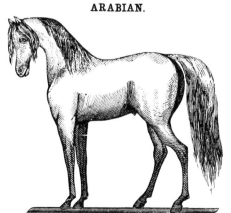

No. 304a. 17 inches long, mounted complete as shown above _ $14 00

DEXTER.

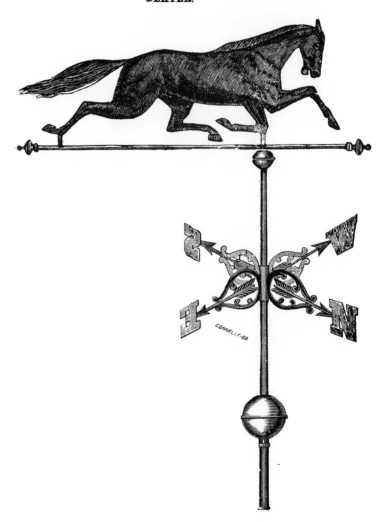

No. 167.	43 inches long					$40 00
" 172.	43	"	"	with Jockey		50 00
" 170.	52	"	"	" Sulky and Driver		55 00
" 173.	57	"	"	" Wagon and Driver		75 00
" 174.	34	"	"			22 00
" 174½.	34	"	"	with Jockey		27 00
' 175.	42	"	"	" Sulky and Driver		32 00
" 176.	50	"	"	" Wagon and Driver		40 00

☞ All our Vanes are made of copper, and gilded with finest gold leaf.

DEXTER.

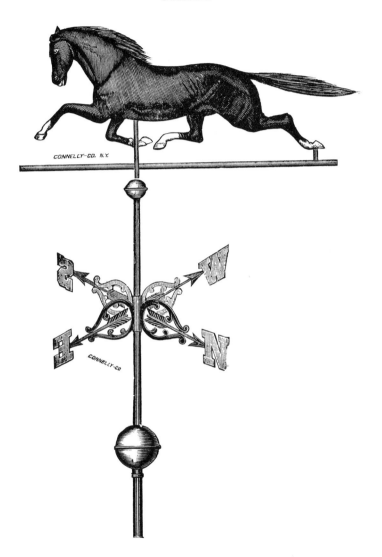

No. 168 A3.	26 inches long,	new design, full bodied		$25 00
" 168¼A3.	26 "	with Jockey		30 00
" 169 A3.	34 "	" Sulky and Driver		35 00
" 165 B3.	42 "	new design, full bodied		50 00
" 165½B3.	42 "	with Jockey		65 00
" 171 B3.	53 "	" Sulky and Driver		75 00

☞All our Vanes are made of copper, and gilded with finest gold leaf.

DEXTER, WITH JOCKEY.

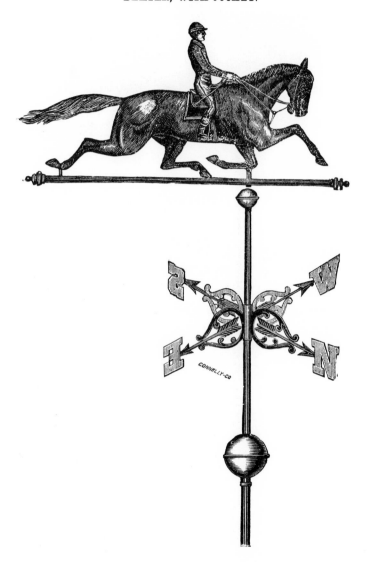

No. 176½. 42 inches long, full bodied, with Jockey_____ _____ $65 00

" 177. 43 " " swell " " " _____ _ ___ _____ 50 00

" 178. 34 " " " " " " _____ 27 00

" 178½. 26 " " full " " " _____ 30 00

☞ All our Vanes are made of copper, and gilded with finest gold leaf.

FOXHALL, WITH JOCKEY.—New Design.

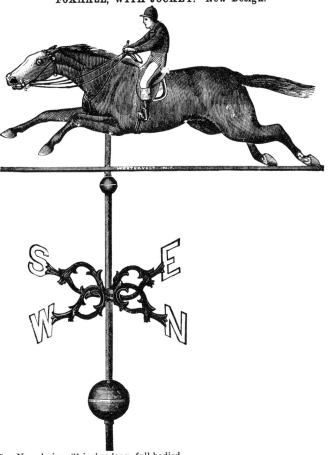

No. 305A. New design, 31 inches long, full bodied$30 00
" 306A. " " 31 " " without Jockey 25 00

KENTUCKY, WITH JOCKEY.

No. 179. New design, 32 inches long, full bodied, mounted complete, as shown above $30 00
" 180. " without Jockey, mounted complete, as shown above 25 00

☞ All our Vanes are made of copper, and gilded with finest gold leaf.

GOLDSMITH MAID.

NEW DESIGN, FULL BODIED.

No. 183.	32 inches long			$30 00
" 184.	40 "	with Sulky and Driver		45 00
" 185.	46 "	" Wagon "		50 00

LEXINGTON.

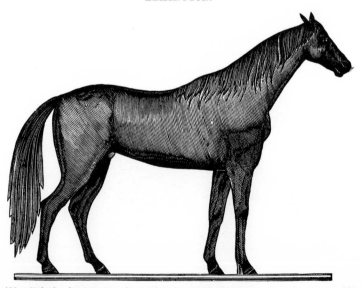

No. 188. 35 inches long, mounted complete, as shown above _____ _____ $30 00

SMUGGLER.

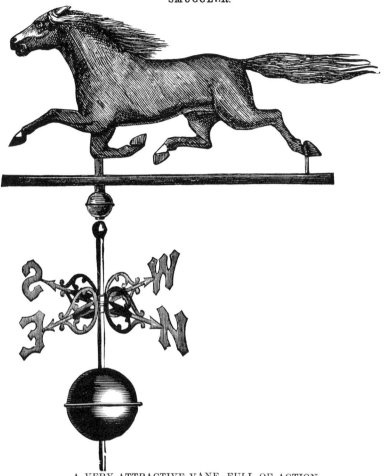

A VERY ATTRACTIVE VANE, FULL OF ACTION.

No. 164. 31 inches long _____$20 00
" 164A. 31 " with Jockey _____ 25 00
" 164B. 36 " " Sulky and Driver_____ 30 00

FARM HORSE.

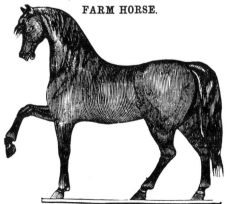

No. 164½. 18 inches long, mounted complete, as shown above_____$14 00
☞ All our Vanes are made of copper, and gilded with finest gold leaf.

HORSE TO WAGON.

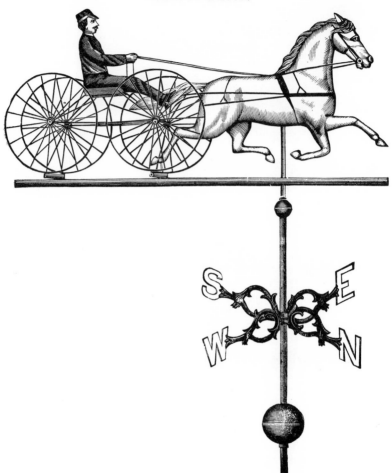

No. 194½ Horse to Wagon, 46 inches long..$50 00

MOUNTAIN BOY

No. 194 33 inches long, new design, full bodied, mounted complete, as shown above. $35 00

☞ All our Vanes are made of copper, and gilded with finest gold leaf.

ETHAN ALLEN, Jr.

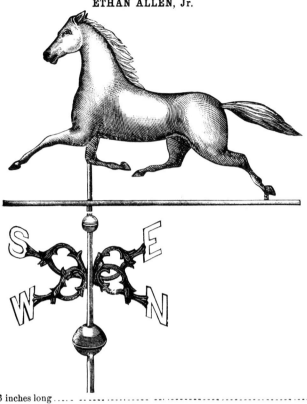

No. 190. 26 inches long ..$15 00
 " 190ᴀ. 30 " with Sulky and D river 25 00
 " 190ʙ.26 " " Jockey .. 20 00

AMERICAN GIRL.

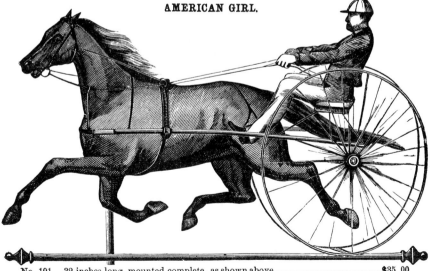

No. 191. 32 inches long, mounted complete, as shown above....................$35 00
 " 192. 36 " with Sulky and Driver, mounted complete, as shown above. 45 00
 " 193. 42 " " Wagon and Driver " " " " 50 00

SHORT HORNED JERSEY COW.

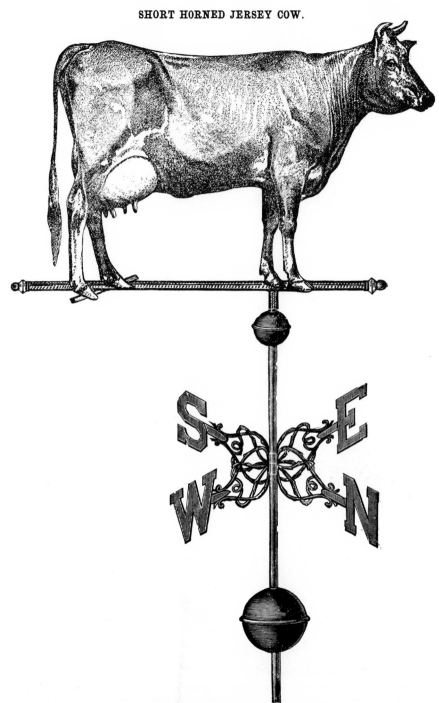

NEW MODEL.—4 FEET LONG.

No 199. 34 inches long .. $65 00
" 200. 48 " " .. 125 00

BULL.

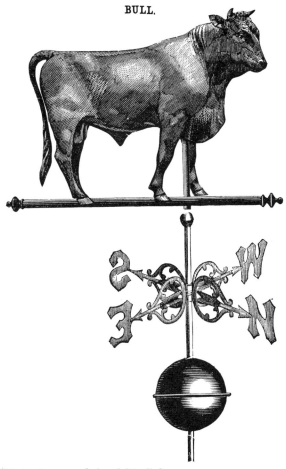

No 195. 28 inches long, new design, full bodied$50 00
" 195¼. 36 " " " " 125 00
" 195ᴀ. 48 " " " " 175 00

COW.

No. 196. 28 inches long, full bodied, mounted complete as shown above...........$30 00
" 197. 42 " " old design, " " 77 00
" 198. 24 " " ... 20 00

OX.

No.	201.	Old design, 28 inches long, mounted complete, as shown below							$25 00	
"	202.	"	24	"	"	"	"	"	"	20 00
"	203.	New design	42	"	"	"	"	"	"	75 00
"	204.	"	34	"	"	"	"	"	"	65 00
"	204¼.	"	36	"	"	"	"	"	"	100 00
"	204A.	"	48	"	"	"	"	"	"	125 00

HOG.

No.	207.	3 feet long	$35 00
"	208.	3 " 6 inches long	50 00
"	208¼.	4 " long	60 00

☞ All our Vanes are made of copper, and gilded with finest gold leaf.

MERINO RAM, ETHAN ALLEN.

No. 206¼. 3 feet long, mounted complete, as shown below......................$50 00

SHEEP.

No. 205. 28 inches long..$25 00

Any other style or size to order.

MERINO RAM, SWEEPSTAKES.

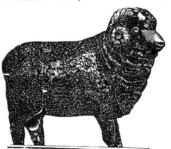

No. 206. 2 feet 6 inches long, mounted complete, as shown above.....................$32 00
" 206A. 3 feet long, " " " " 50 00

SPORTSMAN'S DOG.

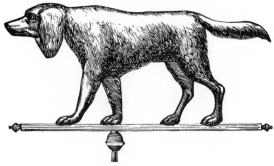

No. 71. 33 inches long, swell bodied, mounted complete, as shown opposite.........$25 00

DOLPHIN OR DRAGON VANE.

No. 72. 26 inches long, full bodied, mounted complete, as shown opposite...........$35 00

OSCEOLA CHIEF.

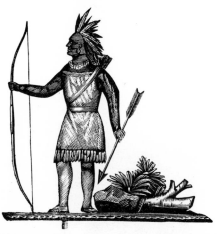

No. 72¼. 30 inches high, mounted complete, as shown opposite.......................$40 00

☞Other sizes and styles to order.

LION.

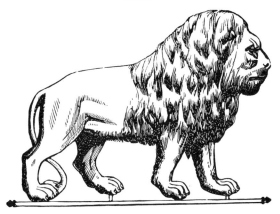

No. 65. 3 feet long, mounted complete, as shown below .. $80 00
" 66. 4 " " " 125 00

LION AND VANE.

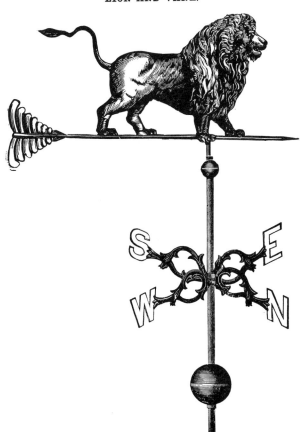

No. 67. 12x24 inches, swell bodied lion, arrow, 3 feet 6 inches long $40 00

RUNNING DEER.

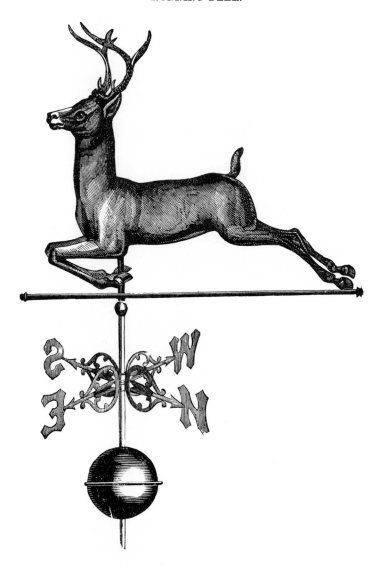

No. 231. New design, 50 inches long, full bodied .. $90 00

" 232. " 36 " " .. 50 00

" 233. " 20 " " .. 30 00

" 234. " 30 " " .. 40 00

☞ All our Vanes are made of copper, and gilded with finest gold leaf.

AMERICAN MOOSE DEER.

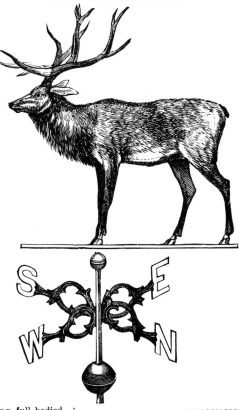

No. 235. 2 feet long, full bodied..$30 00
" 235½. 2 feet 6 inches long, full bodied............................. 40 00
" 235A. 3 " " " ... 50 00

<div align="center">Other sizes to order.</div>

LEAPING DEER.—New Design.

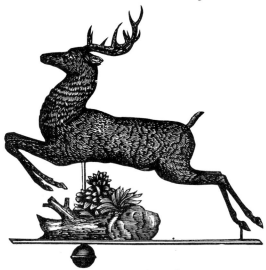

No. 236. 31 inches long, mounted complete, as shown above.....................$40 00
" 236½. 31 " without bush, " " 35 00

FISH VANE.—New Design.

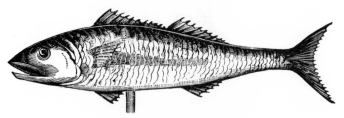

No. 307. 30 inches long, new design, full bodied, mounted complete, as shown below, $30 00

" 308. 38 " " " " " " " " 40 00

FISH VANE.

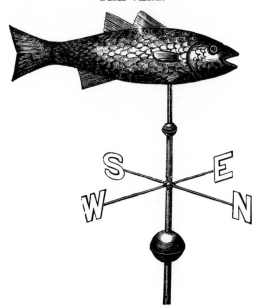

No. 209½. 18 inches long, full bodied ... $15 50

" 209. 24 " " ... 17 50

" 210. 30 " " ... 20 00

" 210½. 36 " " ... 30 00

" 210A. 42 " " ... 40 00

FISH SIGNS.—Flat.

No. 211. Fish for swinging signs, 9 inches long $3 00

" 212. " " " 16 " 4 00

Any size of the above styles to order.

☞ The price of each Vane includes a wrought iron spire, points of compass, and gilt letters and balls.

NEW DESIGN, PIGEON ON BALL, WITH ARROW.

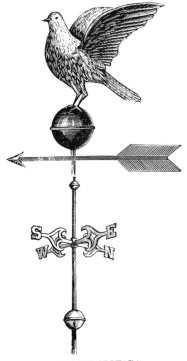

(WINGS SPREAD.)

No. 146. New design, full bodied, 18 inches high, including ball and arrow, with 2 feet arrow......$28 00
" 147. " " 18 " " " " " 2 ft. 6 in. arrow...32 00

NEW DESIGN, PIGEON ON BALL, WITH ARROW.

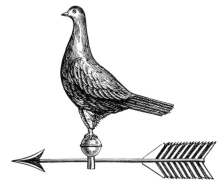

(WINGS FOLDED.)

No. 148. New design, full bodied, 18 inches high, including ball and arrow, with 2 feet arrow $20 00
" 149. " " 18 " " " " " 2 " 6 in. arrow 24 00

Mounted complete, as shown above.

☞ All our Vanes are made of copper, and gilded with finest gold leaf.

NEW DESIGN, CROWING ROOSTER ON BALL, WITH ARROW. (Wings Spread.)

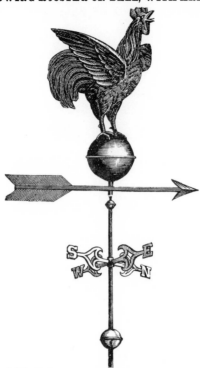

No. 142. New design, full bodied rooster, 21 inches high (including ball and arrow),
with 2 feet 6 inches arrow --- ----------$38 00
" 143. With 2 feet arrow-- 35 00

NEW DESIGN, CROWING ROOSTER ON BALL, WITH ARROW. (Wings Closed.)

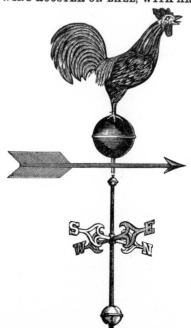

No. 144. New design, full bodied crowing rooster, 21 inches high (including ball and
arrow), with 2 feet 6 inches arrow----------------------------- -------$34 00
" 145. With 2 feetarrow-- ---- 30 00

GAME ROOSTER.

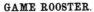

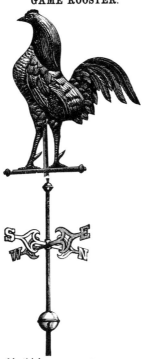

No. 162. 18 inches high, double thickness copper------------------------------$10 00

GAME ROOSTER AND ARROW VANE.

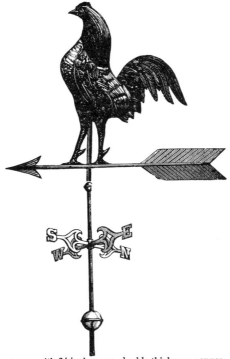

No. 153. 18 inches high, with 24 inch arrow, double thickness copper-------------$16 00
" 154. 18 " " " 30 ' " " " -------------- 20 00

CROWING ROOSTER.

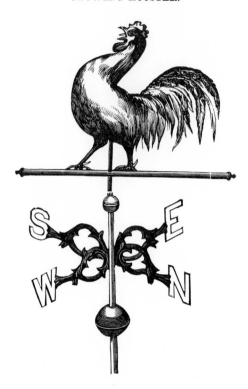

No. 155. 36 inches high --- $40 00

" 156. 24 " -- 30 00

" 157. 18 " --- 20 00

EAGLE AND ARROW.—New Design.

No. 77. 6 inch spread eagle and 24 inch arrow, mounted complete, as shown above.. $12 00

" 78. 6 " " " 30 " " " " " .. 15 00

" 79. 12 " " " 36 " " " " " .. 20 00

" 79½.15 " " " 42 " " " " " .. 30 00

☞ All our Vanes are made of copper, and gilded with finest gold leaf.

MEDIÆVAL ROOSTER VANE FOR CHURCHES.

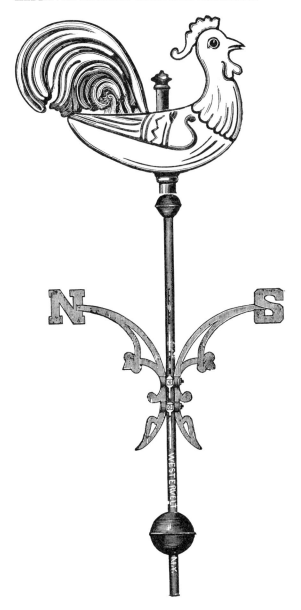

No. 309. 2 feet 6 inches high, as shown above..$50 00

" 310. 3 " " " " .. 70 00

" 311. ·2 " 6 inches " mounted as shown on page 34........................ 40 00

" 312. 3 " " " ⁚ " 60 00

☞All our Vanes are made of copper, and gilded with finest gold leaf.

NEW DESIGN ROOSTER AND ARROW VANE.

No. 150. 15 inches high, with 18 inch Arrow .. $14 00

" 151. 26 " " 30 " ... 30 00

" 152. 32 " " 36 " ... 40 00

" 152½. 42 " " 60 " ... 60 00

☞ All our Vanes are made of copper, and gilded with finest gold leaf.

NEW DESIGN ROOSTER VANE.

Engraved from a photograph of our Work.

(SWELL BODIED, COPPER.)

No.	158.	36 inches high	$35 00	with 4 feet arrow	$50 00				
"	159.	28 "	25 00	" 3 " "	40 00				
"	160.	24 "	15 00	" 30 inches "	25 00				
"	161.	14 "	7 50	" 24 " "	15 00				

Rooster standing on Arrow, as shown on page 31—Game Rooster.

EAGLE AND PEN VANE.

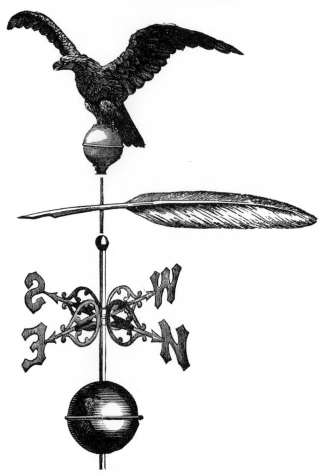

Very handsome, attractive Vanes, especially designed for Schools, Colleges, Academies, Newspaper Buildings, &c., &c.

No. 92.	8 feet spread	with 10 feet Pen,	$275 00
" 93.	7 " "	" 8 "	225 00
" 94.	6 " 6 inches spread	" 7½ "	200 00
" 95.	5 " 6 "	", 6½ "	175 00
" 96.	5 " spread	" 6 "	150 00
" 97.	4 " 6 inches spread	" 5½ "	110 00
" 98.	4 " spread	" 5 "	85 00
" 99.	3 " 6 inches spread	" 4½ "	65 00
" 100.	3 " spread	" 4 "	55 00
" 101.	2 " 6 inches spread	" 3½ "	50 00
" 102.	2 " spread	" 3 "	35 00
" 103.	1 " 6 inches spread	" 30 inch Pen,	25 00
" 104.	1 " 3 "	" 24 "	18 00
" 105.	1 " spread	" 18 "	12 00

COPPER EAGLE WITH ARROW.

Engraved from a Photograph of our work.

We make a PERFECT EAGLE, wholly of Copper, with double thick wings

Arrows are indispensable when Eagles are used as Vanes.

No. 106.	12 feet spread			$500 00
" 107.	10 " "			425 00
" 108.	8 " "			300 00
" 109.	7 " "			225 00
" 110.	6 " 6 inches spread			185 00
" 111.	5 " 6 "			150 00
" 112.	5 " spread			135 00
" 113.	4 " "			70 00
" 114.	3 " 6 inches spread			50 00
" 115.	3 " spread			47 00
" 116.	2 " 6 inches spread			35 00
" 117.	2 " spread			25 00
" 118.	1 foot 6 inches spread			21 00
" 119.	1 " 3 "			15 00
" 120.	1 " spread			10 00

NEW DESIGN EAGLE AND SCROLL VANE.

No. 121.	Eagle,	15 inches spread with	3 feet scroll	$28 00
" 122.	"	20 "	" 3½ "	35 00
" 123.	"	30 "	" 4 "	45 00
" 124.	"	36 "	" 5 "	75 00
" 124½.	"	48 "	" 6 "	100 00

☞ All our Vanes are made of copper, and gilded with finest gold leaf.

EAGLES WITHOUT ARROWS FOR FLAG POLES.—Of Copper.

No. 125.	6 inches spread, on ball and base or ball and stem	$4 00
" 126.	12 " " " " "	9 00
" 127.	15 " " " " "	12 00
" 128.	18 " " " " "	15 00
" 129.	24 " " " " "	20 00
" 130.	30 " " " " "	31 00
" 131.	36 " " " " "	37 00
" 132.	42 " " " " "	40 00
" 133.	48 " " " " "	60 00
" 134.	4 feet 6 inches spread, on ball and base or ball and stem	70 00
" 135.	5 " " " " " "	110 00
" 136.	5 " 6 " " " " "	125 00
" 137.	6 " . " " " " "	140 00
" 138.	6 " 6 " " " " "	150 00
" 139.	7 " " " " " "	170 00
" 140.	7 " 6 " " " " "	200 00
" 141.	8 " " " " " "	225 00

☞ All our Vanes are made of copper, and gilded with finest gold leaf.

CAST ZINC EAGLES.

For Flag Poles, Lamps, Store Signs, Monuments, &c., are not suitable for Vanes.

3 inches spread		$1 25
4	"	2 25
6½	"	3 25
7	"	4 00
10	"	5 00
13	"	8 00
14	"	10 00
18	"	15 00
22	"	16 50
30	"	24 00
31	"	38 00
50	"	50 00
60	"	96 00

FLAG POLES.

25 feet long, 5 inches diameter at Butt					$10 00
30	"	6	"	"	15 00
35	"	6	"	"	18 00
40	"	7	"	"	23 00
40	"	8	"	"	27 00
45	"	8	"	"	35 00
50	"	8	"	"	40 00
50	"	9	"	"	45 00
55	"	9	"	"	55 00
60	"	9	"	"	70 00
60	"	10	"	"	75 00
65	"	11	"	"	100 00
70	"	11	"	"	110 00

BEST LIGNUM-VITÆ TRUCKS.

3 inch	$ 50	Fitted with brass wheels				$1 00
3½ "	70	"	"	"		1 20
4 "	1 00	"	"	"		1 40
4½ "	1 20	"	"	"		1 60
5 "	1 30	"	"	"		1 80
5½ "	1 40	"	"	"		2 40
6 "	2 00	"	"	"		3 00
7 "	2 50	"	"	"		3 75
8 "	3 50	"	"	"		5 00

METAL BALLS FOR FLAG POLES.

Metal Balls on Stems, gilded with Pure Gold Leaf, for Flag-staffs.

	Each.
3 inches	$ 70
4 "	1 10
5 "	1 40
6 "	2 00
7 "	3 00
8 "	3 50
9 "	6 00
10 "	7 75
12 "	12 00

Metal Balls, not on Stems, gilded with Pure Gold, for Vanes or other purposes.

	Each.
1 inch	$ 25
2 inches	35
2½ "	45
3 "	60
4 "	95
5 "	1 25
6 "	1 55
7 "	2 60
8 "	3 00
9 "	4 50
10 "	5 00
12 "	7 50
15 "	18 75
18 "	25 00

FLAG POLE BALLS OF BEST SEASONED WHITE WOOD.

2 inches diameter, each			$ 30
2½ " "			55
3 " "			65
4 " "			1 30
5 " "			1 80
6 " "			2 50
7 " "			3 50
8 " "			4 50
9 " "			5 50
10 " "			6 75

METAL STARS.

	9 in.	12 in.	15 in.	18 in.	24 in.
5 points	$4 00	$5 50	$7 50	$10 00	$16 00
6 "	5 00	6 50	8 50	11 00	17 00
9 "	10 00	13 00	17 00	22 00	34 00
10 "	12 00	15 00	19 00	25 00	37 00
12 "	14 00	17 00	21 00	28 00	40 00
14 "	16 00	18 00	25 00	33 00	50 00

Any other size made to order.

FLAG POLE ORNAMENTS.

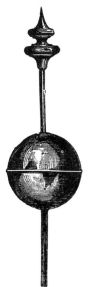

Balls and 5 Points Stars.			
3 in. ball, 4 in. star	$2 20		
4 " 5 "	3 50		
5 " 6 "	4 50		
6 " 7 "	5 50		
8 " 9 "	7 50		
10 " 12 "	13 25		
12 " 15 "	19 50		
15 " 18 "	25 00		

3 inch ball	$1 00
4 "	1 50
5 "	2 00
6 "	2 75
7 "	4 00
8 "	4 50
9 "	7 50
10 "	9 00
12 "	14 00

MALT SHOVEL VANE.

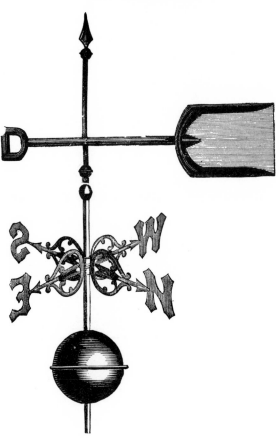

No. 51A.	3 feet long	$25 00
" 51½.	3 " 6 inches long	35 00
" 51B.	4 " long	50 00

HOOK AND LADDER AND NUMBER VANE.

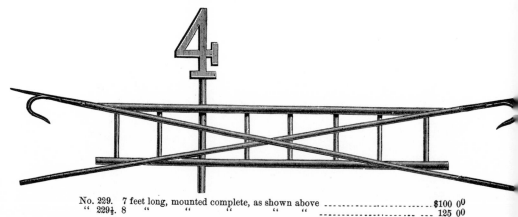

No. 229.	7 feet long, mounted complete, as shown above	$100 00
" 229½.	8 " " " " "	125 00

☞ All our Vanes are made of copper, and gilded with finest gold leaf.

HOSE CARRIAGE VANE.

No. 230. 3 feet 6 inches long, mounted complete, as shown on page 44$85 00
" 230½. 4 " 6 " " " " " " 44...............100 00

Also made with horse and driver. Any size made to order.

HOOK AND LADDER VANE.

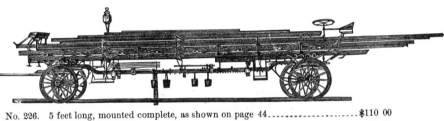

No. 226. 5 feet long, mounted complete, as shown on page 44...................$110 00
" 226½. 6 " " " " " 44..................... 130 00

Made with horses and men to order.

STEAM FIRE ENGINE VANE.

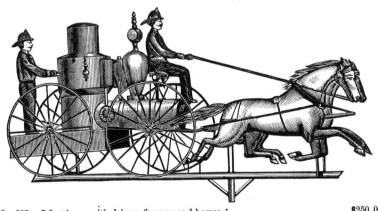

No. 225. 7 feet long, with driver, firemen and horses...........................$250 00
" 225½. 5 " " " " 175 00

Mounted complete, as shown on page 44.

☞ For Firemen's Hat and Trumpet Vane, see page 88.

LIBERTY CAP AND ARROW VANE

No. 25. Liberty Cap, 12 inches high, Arrow 24 inches long_____ _____$20 00

 " 26. " 18 " " 30 " _____ 40 00

 " 27. " 24 " " 36 " _____ 55 00

 " 28. " 36 " " 60 " _____ 85 00

The price of each Vane includes a wrought iron spire with points of compass, gilt letters and balls.

GUN AND CAP VANE.

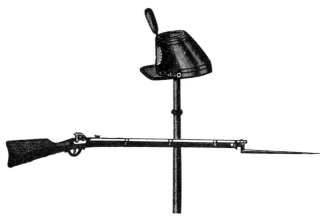

No. 30.	Gun 4 feet long, mounted complete, as shown opposite	$45 00
" 31.	" 5 " " " "	55 00
" 32.	" 6 " " " "	65 00
" 33.	" 7 " " " "	75 00
" 34.	" 8 " " " "	100 00

COPPER FLAG.

No. 42.	18 inches Flag	$12 00
" 43.	24 "	18 00
" 44.	36 "	30 00

LIBERTY CAP.

No. 35.	6 inches high	$7 50
" 36.	9 "	12 00
" 37.	12 "	15 00
" 38.	15 "	20 00
" 39.	18 "	30 00
" 40.	24 "	40 00

☞ **All our Vanes are made of copper, and gilded with finest gold leaf.**

GODDESS OF LIBERTY.

No. 41, 24 inches high, mounted complete, as shown below $30 00
" 41A, 36 " " " " 45 00
" 41B, 48 " " " " 75 00

CANNON.

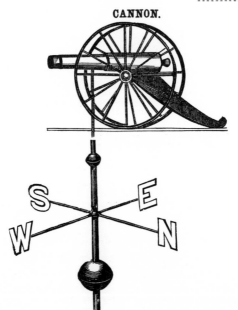

No. 45, 20 inches long $30 00 No. 45½, 30 inches long $45 00

YACHT VANE.

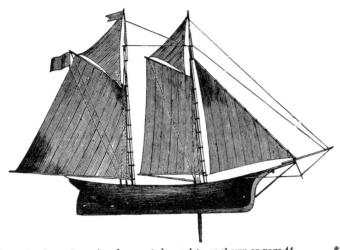

No. 213. 3 feet long, sloop rigged, mounted complete, as shown on page 44 $38 00
" 214. 4 " " " " " " 45 00
" 215. 3½ " schooner rigged, " " " " 60 00
" 216. 3 " " " " " " 48 00

SHIP VANE.

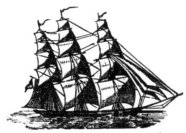

No. 217. 3 feet long, mounted complete, as shown on page 44 . $75 00
" 218. 4 " " " " " 100 00

Any size or design made to order.

OCEAN STEAMER.

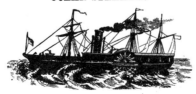

No. 219. 4 feet 6 inches long, mounted complete, as shown on page 44 $110 00

Any size or design made to order.

BUGGY.

No. 227. 42 in. long, mounted complete..$75.00
Any other size made to order.

PLOW.

Mounted complete.

No. 228................36 in. long..$24 00
" 228½.............54 " .. 36 00
Any other size made to order.

HORSE CAR.

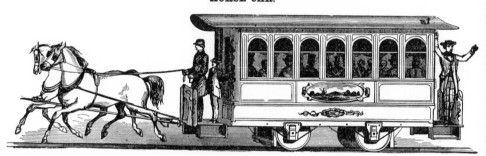

No. 220. 66 inches long, perfect model, with pair of " Ethans " attached, driver and
conductor, mounted complete, as shown on page 50.....$200 00
Any other size made to order.

LOCOMOTIVE AND TENDER,

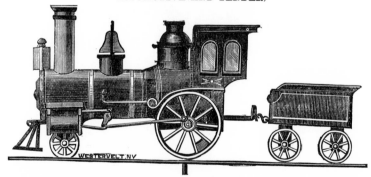

Mounted complete, as shown on page 50.

No. 221. 72 in. long, with Tender, perfect full-bodied model, extra work..........$200 00
" 222. 48 " " " " " " 150 00
" 223. Locomotive and Tender, 5 feet long......... 75 00
" 224. " without Tender......... 50 00

☞All our Vanes are made of copper, and gilded with finest gold leaf.

GRECIAN BANNERET, WITH SCROLL.

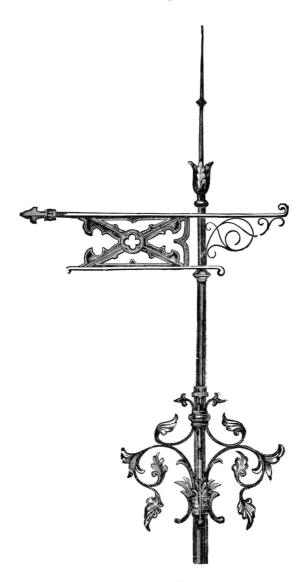

Banneret of Copper, Scroll Decorated in Gold and Colors.

No. 1. 3½ feet, 4 sided, as shown above, with scroll ..$70 00
" 2. 3½ " mounted as shown on page 50, without scroll 65 00
" 3. 4½ " 4 sided, as shown above, with scroll 80 00
" 4. 4½ " mounted, as shown on page 50, without scroll 75 00

☞ All our Vanes are made of copper, and gilded with finest gold leaf.

TIFFANY VANE.

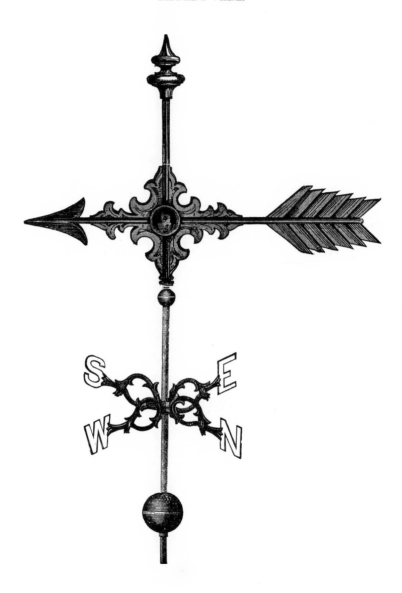

No. 276½. 5 feet long ..$45 00
" 277. 6 " .. 60 00
" 278. 7½ " .. 80 00

☞ All our Vanes are made of copper, and gilded with finest gold leaf.

CHURCH OR SCROLL VANE.

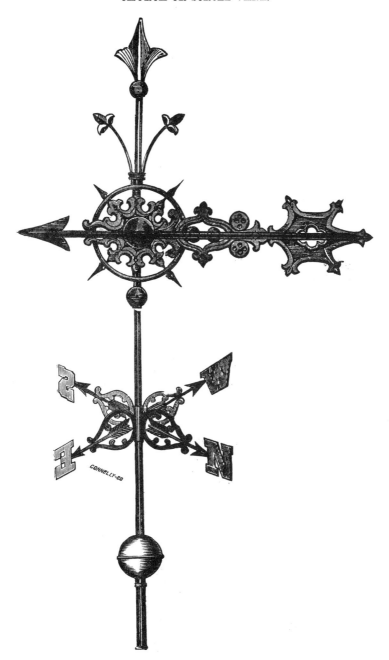

No. 282. 6 feet long ... $90 00
" 283. 7 " .. 120 00
" 284. 8 " .. 140 00

☞ All our Vanes are made of copper, and gilded with finest gold leaf.

CENTENNIAL SCROLL VANE.—New Design.

No. 285. 5 feet long _____ $80 00
 " 286. 6 " _____ 100 00
 " 287. 7 " _____ 130 00
 " 288. 8 " _____ 150 00

☞ All our Vanes are made **of copper**, and gilded with finest gold leaf.

NEW DESIGN CHURCH VANE.

No. 313. 6 feet long .. $100 00
" 314. 7 " .. 130 00
" 315. 8 " .. 140 00

☞ All our Vanes are made of copper, and gilded with finest gold leaf.

NEW DESIGN SCHOOL AND LOCOMOTIVE VANE.

No. 6. 6 feet long .. $140 00
" 6½. 7 " ... 155 00

NEW DESIGN BANNERET.

No. 18. 4 feet long$65 00
" 18¼. 4 " 6 inches long............ 70 00

☞ Any number, monogram or initial cut in panel without extra charge.

SIGN VANE, WITH ANY NAME.

Letters in Name Decorated in Black.

No. 76½. A. 6 feet long .. $90 00
" 76½. B. 7 " .. 120 00
" 76½. C. 8 " .. 150 00

☞ All our Vanes are made of copper, and gilded with finest gold leaf.

METROPOLITAN SCROLL VANE.

No. 68.	6 feet long		$80 00
" 69.	7 "		90 00
" 70.	8 "		125 00

☞ All our Vanes are made of copper, and gilded with finest gold leaf.

BREWERS' AND MALSTERS' VANE.

MALT SHOVEL AND BARREL, EITHER SEPARATE OR TOGETHER.

No. 52. Shovel 5 feet long, Barrel raised 6 inches $80 00

" 53. " 5 " without Barrel ... 60 00

" 53½. " 6 " Barrel raised 6 inches 95 00

" 54. " 6 " without Barrel 75 00

" 54½. " 7 " Barrel raised 7 inches 120 00

" 55. " 7 " without Barrel 90 00

☞ **Any size Shovel made to order with Barrel.**

SCROLL SIGN VANE WITH BARREL.—New Design.

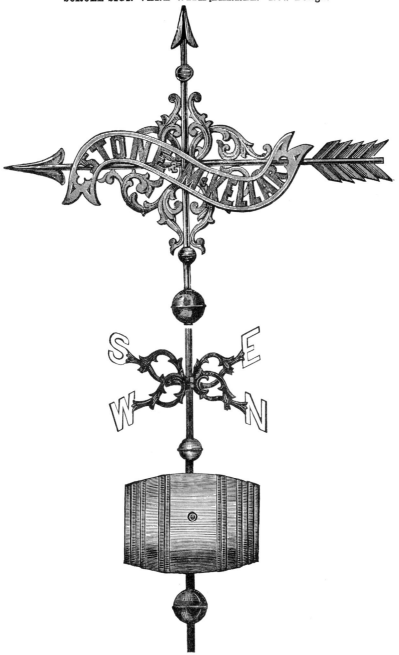

Made with any Name.

No. 63. 5 feet long, with Barrel raised 6 inches................................$100 00
 " 63. A. 6 " " " " 125 00
 " 63. B. 5 " without Barrel................................. 80 00
 " 63. C. 6 " " .. 100 00
 " 63. D. 7 " 6 inches " .. 130 00

☞ **Handsomely mounted with Spire, Letters and Balls complete.**

NEW DESIGN CHURCH OR SCROLL VANE.

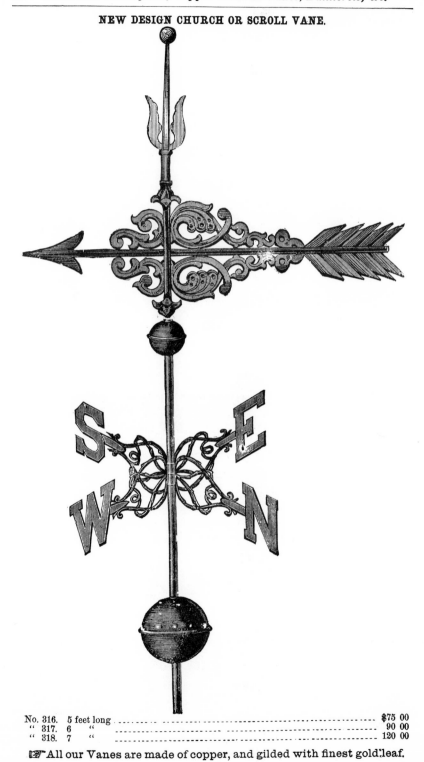

No. 316.	5 feet long	$75 00
" 317.	6 "	90 00
" 318.	7 "	120 00

☞ All our Vanes are made of copper, and gilded with finest gold leaf.

ENGLISH BANNERET.

No. 292½. 3 feet 6 inches long_____$50 00

☞ All our Vanes are made of copper, and gilded with finest gold leaf.

NEW DESIGN BANNERET, CROWN AND FINIAL VANE.

No. 319. Banneret, 4 feet long, complete as shown above....................$130 00

Gilded and decorated in any color. Any size made to order.

NEW DESIGN BANNERET AND SCROLL VANE.

No. 320. Banneret, 3 feet long, scroll copper and gilded_____$100 00

" 321. " " mounted complete, as shown on page 60_____ 50 00

DOMINICAN CROSS AND VANE.—New Design.

No. 302 A. 16 feet high, Copper and Brass, gilded._____$350 00

☞ **Any** other design made to order.

ROMAN BANNERET.

No. 290. 3 feet long, ornaments of Iron, 4 sides, gilded and decorated in any color. $70 00
" 291. 3 " 6 inches long, " " 4 " " " " 85 00
" 292. 4 " long, " " 4 " " " " 100 00

☞ **Vanes of any design made to order at reasonable prices.**

NEW DESIGN BANNERET AND FINIAL.

No. 322. 2 feet 9 inches long, as shown above ..$44 00
" 323. 2 " 9 " mounted, as shown on page 81......................... 50 00

☞ Banneret of copper and gilded, finial of iron, decorated in gold and colors.

NEW DESIGN BANNERET AND FINIAL.

No. 324. 3 feet long, as shown above. .$46 00

" 325. 3 " mounted, as shown on page 81. 52 50

☞ Banneret of copper and gilded, finial of iron, decorated in gold and colors.

ANTIQUE INITIAL AND HORSE BANNERET VANE.

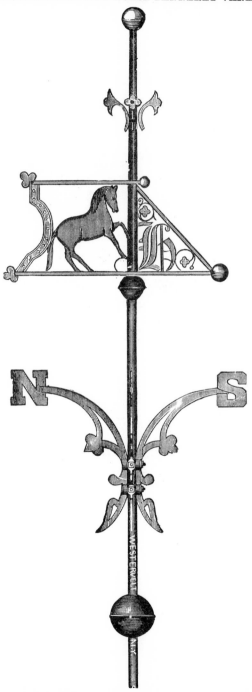

No. 5. 4 feet long, as shown above._____ $85 00
 " 5¼. 5 " " " _____ 100 00

☞ **Banneret of copper and gilded, points of compass of iron, decorated in gold and colors.**

NEW DESIGN BANNERET.

No. 326. 3 feet long, as shown above..$52 50
" 327. 3 " " on page 81.................................... 47 50

☞Banneret of Copper and gilded, points of compass of iron, and decorated in gold and colors.

NEW DESIGN BANNERET.

No. 328. 3 feet long, as shown above..$50 00

" 329. 3 " " on page 81... 45 00

☞**Banneret** of copper and gilded, points of compass of iron, and decorated in gold and colors.

NEW DESIGN BANNERET.

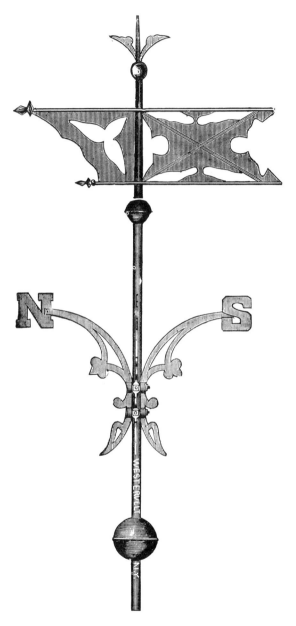

No. 330. 3 feet 6 inches long, as shown above$60 00

 " 331. 3 " " " " on page 81...................... 55 00

☞Banneret of Copper and gilded, points of compass of iron, and decorated in gold and colors.

NEW DESIGN BANNERET.

No. 332. 3 feet long, as shown above._____$55 00
 " 333. 3 " " on page 81 _____ 50 00

☞ **Banneret of Copper, points of compass of iron, decorated in gold and colors.**

No. 334. 3 feet long, as shown above..$50 00
" 335. 3 " " on page 81................. 45 00

☞**Banneret** of copper and gilded, points of compass, of iron, and decorated in gold and colors.

NEW DESIGN BANNERET.

No. 336. 3 feet long, as shown above..$55 00

" 337. 3 " " on page 81.. 50 00

☞Banneret of copper, points of compass of iron, decorated in gold and colors.

NEW DESIGN BANNERET.

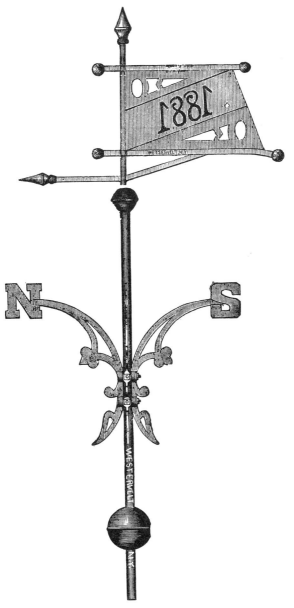

No. 338. 3 feet long, as shown above..$50 00

339. 3 " " on page 81.. 45 00

☞ **Banneret of Copper and gilded, points of compass of iron, and decorated in gold and colors.**

Any number or initial cut in panel without extra charge.

NEW DESIGN BANNERET.

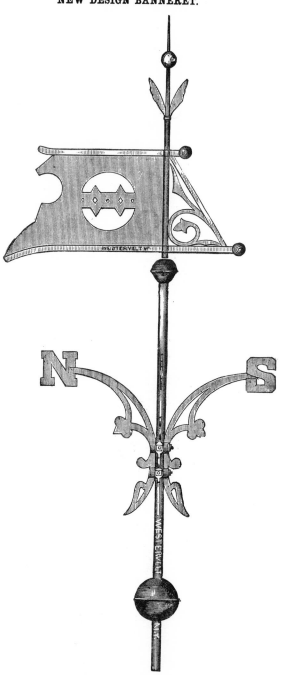

No. 340. 3 feet long, as shown above..$46 00

" 341. 3 " " on page 81... 42 50

☞ Banneret of copper, points of compass of iron, decorated in gold and colors.

NEW DESIGN STAR AND CRESCENT BANNERET.

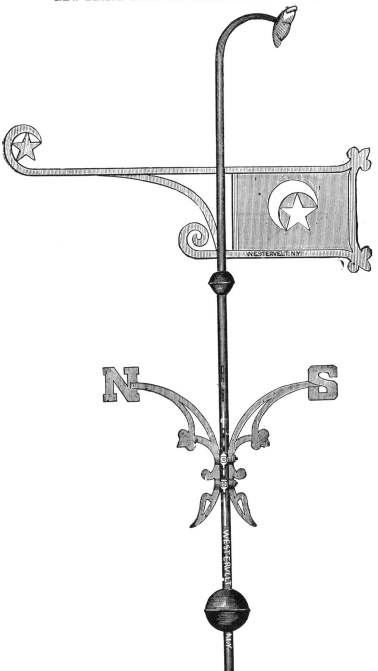

No. 342. 3 feet long, as shown above._____$55 00
" 343. 3 " " on page 81_____ 50 00

☞ Banneret of Copper and gilded, points of compass of iron, and decorated in gold and colors.

NEW DESIGN BANNERET.

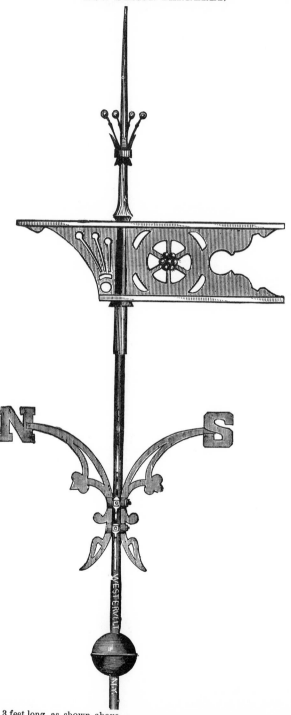

No. 344. 3 feet long, as shown above_____$55 00
" 345. 3 " " on page 81._____ 50 00
 ☞Banneret of Copper and gilded, points of compass of iron, and decorated in
gold and colors

NEW DESIGN BANNERET.

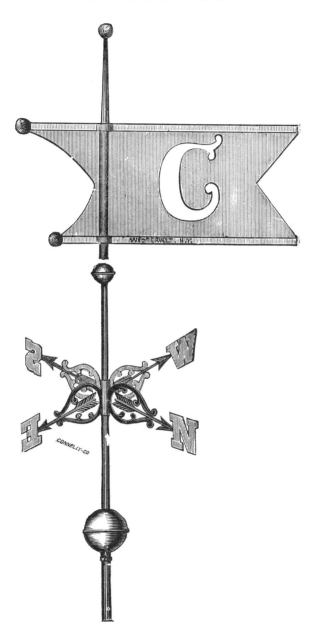

No. 346. 2 feet 6 inches long ... $30 00

" 347. 3 feet long ... 42 50

☞ All our Vanes are made of copper, and gilded with finest gold leaf.

ARROW VANE.

<div align="center">

All our **ARROW VANES** are corrugated, thus greatly increasing their strength and beauty.

</div>

No. 246 b.	96 inches long			$100 00
" 246 a.	84	"		70 00
" 246	72	"		50 00
" 247	60	"		30 00
" 248	48	"		20 00
" 249	42	"		18 00
" 250	36	"		15 00
" 251	20	"		10 00
" 252	24	"		8 00
" 253	18	"		6 00
" 254	15	"		5 00
" 255	12	"		4 00

<div align="center">

The above prices are with Spire, appropriate Letters and Balls complete.

</div>

CHURCH OR SCROLL VANE.

No. 256.	Scroll Vanes 12 feet long	$125 00	No. 265.	Small scroll, 4 feet long	$20 00
" 257.	" 10 "	100 00	" 266.	" 3½ "	18 00
" 258.	" 8 "	90 00	" 267.	" 3 "	15 00
" 259.	" 7 "	80 00	" 268.	" 2½ "	12 00
" 260.	" 6 "	65 00	" 269.	" 24 inches long	10 00
" 261.	" 5½ "	45 00	" 270.	" 18 "	8 00
" 262.	" 5 "	35 00	" 271.	" 15 "	6 00
" 263.	" 4½ "	25 00	" 272.	" 12 "	5 00
" 264.	" 4 "	23 00	" 273.	" 8 "	4 50

SCROLL VANE.

No. 22. 28 inches long, mounted complete, as shown above ____ _____$14 00

LYRE BANNERET.—For Music Halls, &c.

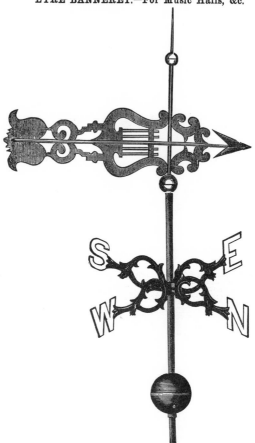

No. 56. 2 feet 6 inches long..$20 00
" 57. 3 feet long... 25 00
" 58. 4 " ... 35 00
" 58½, 5 " ... 45 00

NEW DESIGN BANNERET.

No. 348. 2 feet 6 inches long, mounted complete, as shown above..................$30 00
" 349. 3 feet long, " " " " 40 00

SCROLL HARP VANE.—New Design.

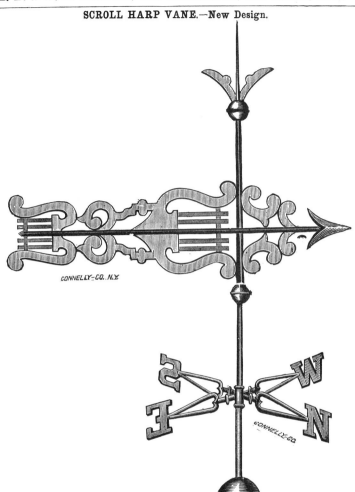

No. 350. 4 feet long $38 00 | No. 351. 5 feet $48 00

NEW DESIGN BANNERET.

No. 352. 2 feet long, mounted complete, as shown above - $2
" 353. 2 feet 6 inches long, mounted complete, as shown above 30 00

ROMAN SCROLL.—New Design.

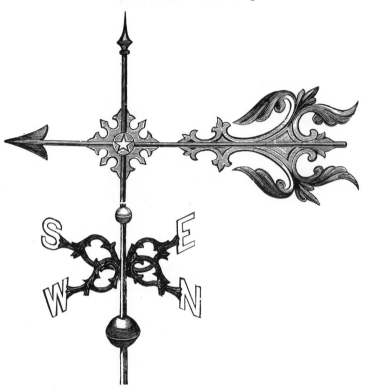

No. 274. 3 feet long‗‗‗‗‗‗‗‗‗‗‗‗‗‗‗‗‗‗‗‗‗‗‗‗‗‗‗‗‗‗‗‗‗‗‗‗‗‗$20 00
 " 275. 4 " ‗‗‗‗‗‗‗‗‗‗‗‗‗‗‗‗‗‗‗‗‗‗‗‗‗‗‗‗‗‗‗‗‗‗ 25 00
 " 276. 5 " ‗‗‗‗‗‗‗‗‗‗‗‗‗‗‗‗‗‗‗‗‗‗‗‗‗‗‗‗‗‗‗‗‗‗ 40 00

SPEAR HEAD SCROLL.

No. 279. 4 feet long, mounted complete, as shown above‗‗‗‗‗‗‗‗‗$20 00
 " 280. 3½ " " " " " ‗‗‗‗‗‗‗‗‗‗ 18 00
 " 281. 3 " " " " " ‗‗‗‗‗‗‗‗‗‗ 15 00

ROMAN SCROLL.—Old Design.

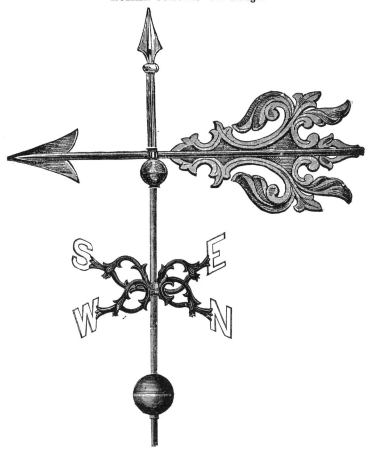

No. 237.	3 feet long.		$20 00
" 238.	4 "		25 00
" 239.	5 "		40 00
" 240.	7 "		50 00

PEN VANE.

Especially designed and adapted for Newspapers, Libraries, Banks, Schools, Colleges, Academies, and other Public Institutions.

No. 241.	2 feet long, mounted complete, as shown above	$12 00
" 242.	3 " " " " "	18 00
" 243.	4 " " " " "	25 00
" 244.	5 " " " " "	40 00
" 245.	6 " " " " "	55 00

SPARKLING VANE,

This is a new and attractive Vane. The fan is covered with a glittering silvery substance, making a very showy appearance while revolving in the wind.

No. 46. 4 feet long. .. $30 00
" 47. 5 " .. 40 00
" 48. 6 " .. 70 00
" 49. 7 " .. 80 00

FIREMAN'S CAP AND TRUMPET VANE.

No. 361. Hat 2 feet long, trumpet 2 feet 6 in. long, mounted complete, as shown above, $50 00
" 362. " 2 " 6 in." " 3 " 6 " " " " " 65 00

NEW DESIGN LYRE BANNERET.—For Music Halls, &c.

No. 354. 3 feet 6 inches long, double thickness........$60 00

NEW DESIGN LYRE BANNERET.—For Music Halls, &c.

No. 355. 3 feet 6 inches long, single thickness, mounted complete, as shown above..$40 00

☞All our Vanes are made of copper, and gilded with finest gold leaf.

INITIAL BANNERET.

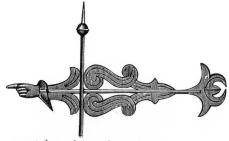

No. 22½ A. 2 feet 6 inches long .. $30 00
" 22½ B. 3 " long .. 35 00
" 22½ C. 3 " 6 inches long .. 45 00
" 22½ D. 4 " long .. 50 00

Any initial, monogram, or number cut in panel without extra charge.

SCROLL WITH INDEX.

No. 73. 3 feet long, mounted complete, as shown above $18 00
" 74. 3 " 6 inches long, mounted complete as shown above. 22 00
" 75. 4 " long, mounted complete, as shown above 25 00
" 76. 5 " " " " " " 35 00

NEW DESIGN MONOGRAM BANNERET.

No. 14. 3 feet long..$50 00
" 14½. 3 feet 6 inches long.... ... 58 00

Any number, monogram or initial cut in panel without extra charge.

NEW DESIGN INITIAL BANNERET.

No. 356. 2 feet 6 inches long, mounted complete, as shown above.............$30 00
" 357. 3 feet long, " " " " 40 00
" 358. 3 feet 6 inches long, " " " " 50 00

Any number, monogram or initial cut in panel without extra charge.

BANNERET, NEW DESIGN.

No. 7. 3 feet 6 inches long. _$50 00
" 7½. 4 feet long _ _ _ _ _ _ 60 00
Any number, monogram or initial cut in panel without extra charge.

SCROLL AND LOCOMOTIVE VANE.

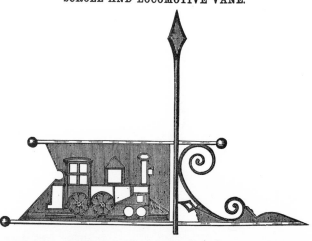

No. 8. 4 feet 6 inches long, mounted complete, as shown above _ _ _ _ _ _ _ _ _ _ _ _ _ _ _$60 00
No. 8½. 5 feet long, " " " ." _ _ _ _ _ _ _ _ _ _ _ _ _ _ _ 70 00
☞ All our Vanes are made of copper, and gilded with finest gold leaf.

NEW DESIGN INITIAL BANNERET.

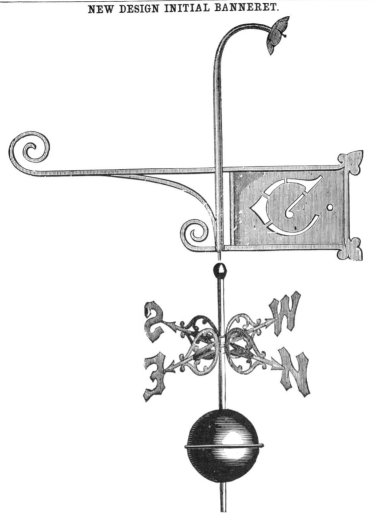

No 11. 3 feet long$45 00 | No. 11½. 4 feet long................$60 00
Any number, monogram or initial cut in panel without extra charge.

NEW DESIGN INITIAL BANNERET.

No. 12. 3 feet long, mounted complete, as shown above.............................$40 00
' 12½. 3 feet 6 inches long, mounted complete, as shown above.................... 50 00
Any number, monogram or initial cut in panel without extra charge.

VANDERBILT BANNERET.—New Design.

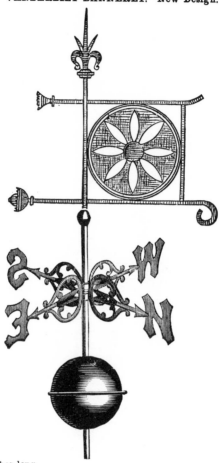

No. 16. 2 feet 6 inches long _$40 00
 " 16½. 3 " long _ 45 00
Any other size made to order,

BANNERET.

No. 62½. 2 feet long, mounted complete, as shown above _$18 00
 " 62. 3 " " " " " " _ _ _ _ _ _ _ _ _ _ _ _ _ _ 20 00
 " 61. 3 feet 6 in. long, mounted complete, as shown above _ _ _ _ _ _ _ _ _ _ _ _ _ _ 25 00
 " 60. 4 " long, mounted complete, as shown above _ _ _ _ _ _ _ _ _ _ _ _ _ 30 00
 " 59. 5 " " " " " " _ _ _ _ _ _ _ _ _ _ _ _ _ _ 35 00
☞ All our Vanes are made of copper, and gilded with finest gold leaf.

BANNERET, NEW DESIGN.

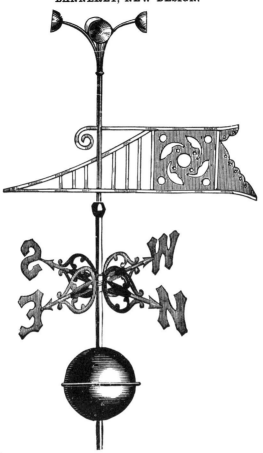

No. 9. 3 feet long..$50 00
" 9½. 4 " ... 65 00

FRENCH SCROLL VANE.

No. 10. 3 feet long, mounted complete, as shown above.........................$40 00
" 10½. 4 " " " " ... 45 00

Any size made to order.

NEW DESIGN BANNERET.

No. 15. 2 feet 6 inches long..$35 00
" 15½ 3 " long... 40 00

NEW DESIGN INITIAL BANNERET.

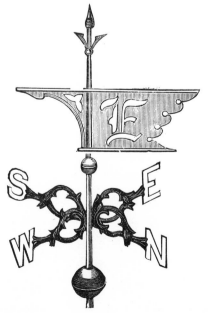

No. 359. 2 feet 6 inches long...$30 00
" 360. 3 " long... 40 00

NEWPORT BANNERET.—New Design.

No. 17. 2 feet 6 inches long........$35 00 | No. 17¼. 3 feet long........$40 00

Any other size made to order.

BANNERET.

No. 19 **A.** 3 feet long, mounted complete, as shown above......................$35 00

" 19½ **B.** 2 " 6 inches long, mounted complete, as shown above............ 30 00

MANHATTAN BEACH HOTEL BANNERET, BLUE AND GOLD.

No. 20. 3 feet long_____ $35 00 | No. 20 A. 4 feet long_____ ___$55 00

BANNERET.

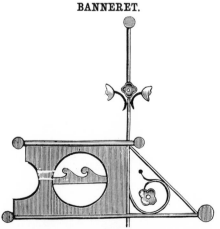

No. 20½ A. 3 feet long, mounted complete, as shown above_____ _____**$35 00**
" 21 B. 2 " 6 inches long, mounted complete, as shown above._____ **25 00**

LIGHTNING CONDUCTORS.

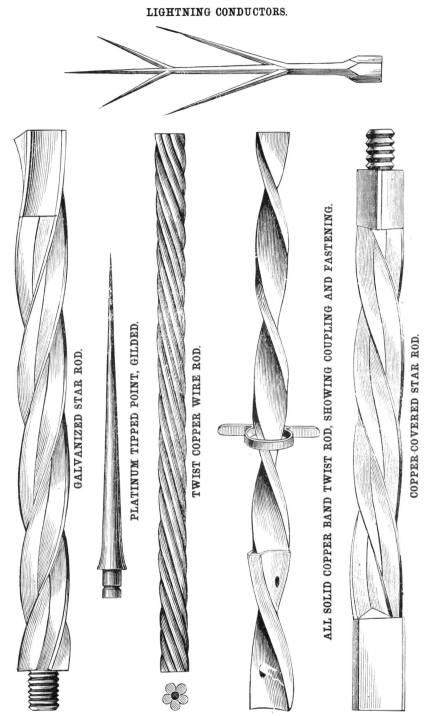

GALVANIZED STAR ROD.

PLATINUM TIPPED POINT, GILDED.

TWIST COPPER WIRE ROD.

ALL SOLID COPPER BAND TWIST ROD, SHOWING COUPLING AND FASTENING.

COPPER-COVERED STAR ROD.

NEW YORK AGENCY FOR LIGHTNING RODS.

A. B. & W. T. WESTERVELT, 102 CHAMBERS STREET, N. Y.

NEW AND IMPROVED
NICKEL-PLATED, POLISHED BRONZE AND IRON
STABLE FIXTURES,

Newest Designs at Lowest Prices. Send for Catalogue and Prices.

CAST CORNER MANGER. **CAST CORNER HAY RACK.**

Corner Manger, Food Guard all around.

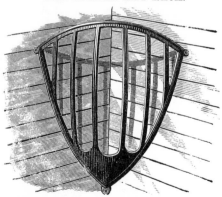

MANUFACTURED BY
A. B. & W. T. WESTERVELT,

No. 102 CHAMBERS STREET,

Cor. Church Street, *NEW YORK.*

Estimates given for all kinds of Wrought and Cast-Iron Work, Copper
Weather Vanes, Finials, Crestings, &c. Catalogues on Application.

No. 6.

WESTERVELT'S

WEATHER VANES

MANUFACTURED BY

A. B. & W. T. WESTERVELT,

OFFICE AND WAREROOMS:

102 CHAMBERS ST.,

Cor. Church Street,

NEW YORK.

BROWN & WOOD, PRINTERS, 26 & 28 VESEY STREET, NEW YORK.

A CATALOGUE OF
SELECTED DOVER BOOKS
IN ALL FIELDS OF INTEREST

A CATALOGUE OF SELECTED DOVER
BOOKS IN ALL FIELDS OF INTEREST

CONDITIONED REFLEXES, Ivan P. Pavlov. Full translation of most complete statement of Pavlov's work; cerebral damage, conditioned reflex, experiments with dogs, sleep, similar topics of great importance. 430pp. 5⅜ x 8½. 60614-7 Pa. $4.50

NOTES ON NURSING: WHAT IT IS, AND WHAT IT IS NOT, Florence Nightingale. Outspoken writings by founder of modern nursing. When first published (1860) it played an important role in much needed revolution in nursing. Still stimulating. 140pp. 5⅜ x 8½. 22340-X Pa. $3.00

HARTER'S PICTURE ARCHIVE FOR COLLAGE AND ILLUSTRATION, Jim Harter. Over 300 authentic, rare 19th-century engravings selected by noted collagist for artists, designers, decoupeurs, etc. Machines, people, animals, etc., printed one side of page. 25 scene plates for backgrounds. 6 collages by Harter, Satty, Singer, Evans. Introduction. 192pp. 8⅞ x 11¾. 23659-5 Pa. $5.00

MANUAL OF TRADITIONAL WOOD CARVING, edited by Paul N. Hasluck. Possibly the best book in English on the craft of wood carving. Practical instructions, along with 1,146 working drawings and photographic illustrations. Formerly titled *Cassell's Wood Carving.* 576pp. 6½ x 9¼.
23489-4 Pa. $7.95

THE PRINCIPLES AND PRACTICE OF HAND OR SIMPLE TURNING, John Jacob Holtzapffel. Full coverage of basic lathe techniques—history and development, special apparatus, softwood turning, hardwood turning, metal turning. Many projects—billiard ball, works formed within a sphere, egg cups, ash trays, vases, jardiniers, others—included. 1881 edition. 800 illustrations. 592pp. 6⅛ x 9¼. 23365-0 Clothbd. $15.00

THE JOY OF HANDWEAVING, Osma Tod. Only book you need for hand weaving. Fundamentals, threads, weaves, plus numerous projects for small board-loom, two-harness, tapestry, laid-in, four-harness weaving and more. Over 160 illustrations. 2nd revised edition. 352pp. 6½ x 9¼.
23458-4 Pa. $6.00

THE BOOK OF WOOD CARVING, Charles Marshall Sayers. Still finest book for beginning student in wood sculpture. Noted teacher, craftsman discusses fundamentals, technique; gives 34 designs, over 34 projects for panels, bookends, mirrors, etc. "Absolutely first-rate"—E. J. Tangerman. 33 photos. 118pp. 7¾ x 10⅝. 23654-4 Pa. $3.50

AMERICAN ANTIQUE FURNITURE, Edgar G. Miller, Jr. The basic coverage of all American furniture before 1840: chapters per item chronologically cover all types of furniture, with more than 2100 photos. Total of 1106pp. 7⅞ x 10¾. 21599-7, 21600-4 Pa., Two-vol. set $17.90

ILLUSTRATED GUIDE TO SHAKER FURNITURE, Robert Meader. Director, Shaker Museum, Old Chatham, presents up-to-date coverage of all furniture and appurtenances, with much on local styles not available elsewhere. 235 photos. 146pp. 9 x 12. 22819-3 Pa. $6.00

ORIENTAL RUGS, ANTIQUE AND MODERN, Walter A. Hawley. Persia, Turkey, Caucasus, Central Asia, China, other traditions. Best general survey of all aspects: styles and periods, manufacture, uses, symbols and their interpretation, and identification. 96 illustrations, 11 in color. 320pp. 6⅛ x 9¼. 22366-3 Pa. $6.95

CHINESE POTTERY AND PORCELAIN, R. L. Hobson. Detailed descriptions and analyses by former Keeper of the Department of Oriental Antiquities and Ethnography at the British Museum. Covers hundreds of pieces from primitive times to 1915. Still the standard text for most periods. 136 plates, 40 in full color. Total of 750pp. 5⅜ x 8½.
23253-0 Pa. $10.00

THE WARES OF THE MING DYNASTY, R. L. Hobson. Foremost scholar examines and illustrates many varieties of Ming (1368-1644). Famous blue and white, polychrome, lesser-known styles and shapes. 117 illustrations, 9 full color, of outstanding pieces. Total of 263pp. 6⅛ x 9¼. (Available in U.S. only) 23652-8 Pa. $6.00

Prices subject to change without notice.

Available at your book dealer or write for free catalogue to Dept. GI, Dover Publications, Inc., 180 Varick St., N.Y., N.Y. 10014. Dover publishes more than 175 books each year on science, elementary and advanced mathematics, biology, music, art, literary history, social sciences and other areas.